INSIDE OUT

Tanika Gupta

INSIDE OUT

OBERON BOOKS
LONDON

First published in 2002 by Oberon Books Ltd.
(incorporating Absolute Classics)
521 Caledonian Road, London N7 9RH
Tel: 020 7607 3637 / Fax: 020 7607 3629

e-mail: oberon.books@btinternet.com
www.oberonbooks.com

A catalogue record for this book is available from the British
Library.

ISBN: 1 84002 352 X

Cover design: Andrzej Klimowski

Typography: Richard Doust

Printed in Great Britain by Antony Rowe Ltd, Chippenham.

Contents

Preface

My great-uncle, Dinesh Gupta, was imprisoned at the age of nineteen by the British in India in 1929. This was for his part in the killing of the Inspector General of prisons. During a stint in Alipore Central jail for six months, Dinesh wrote many letters to his family, in both English and Bengali, and it was reading these beautiful letters which inspired me to start writing plays many years ago. My great-uncle was in fact hanged in 1930, as a 'terrorist', and although I never met him, I felt as if I had a connection with him through his written words. He is now recognised as a freedom fighter in India and the main square in Calcutta's business area has been renamed in honour of his and his fellow compatriots honour – BBD BAGH (Badal, Binoy, Dinesh Square). There is even a statue of him! Because of this little piece of family history, I have often ruminated on the subject of crime and punishment.

As the Clean Break commissioned writer for 2002, my play *Inside Out* evolved after a three-month stint, running writing workshops at Winchester Women's prison. Having never set foot inside a prison, this was to be a rather life-changing experience for me. I had an amazing group of women who came regularly to the writing workshops. They came from as far flung places as northern China, Brazil, Jamaica, the US and St Kitts. All of them were keen to write, to share their loss, their joys and memories and indeed to support each other's writing. As each week progressed, so the writing became more and more emotional and correspondingly rich with the condition of the human experience and I was often moved to tears.

I could not and still do not believe that locking people up is an effective solution. Almost all the women inmates I met at Winchester were from impoverished backgrounds whose lives had dealt them a very bad hand. I was shocked to see how many black women languished inside for relatively minor offences, serving long sentences for trying to cheat their way out of poverty and deprivation.

No single story can capture all the issues involved with women in the criminal justice system. Hence, it was important for me, after immersing myself in the research, to then focus on writing a drama, looking closely at characters and plot. I was particularly interested in how crime and punishment could affect a family. *Inside Out* is at heart therefore simply a story of two sisters.

I'd like to say a big thank you to all the staff at Clean Break who helped me enormously in my research period. More specifically thanks to Susannah Kraft Levine, Lillie Stout, Lucy Perman and Fay Barrat for their encouragement. A special thanks goes to Irma Innis for her work on the script. Thanks also to Ita Harris, the education officer at Winchester prison, for her support during my workshops and to my friend and mentor Lin Coghlan for her advice and wisdom. Thanks also of course to the women who attended the writing workshops at Winchester, for opening my eyes and sharing their amazing stories with me. Finally thanks to Natasha Betteridge and the cast for breathing life into my play.

Tanika Gupta
October 2002

Clean Break

Clean Break is the only women's theatre company in the UK that works with women in prison, women ex-offenders and women who have been sectioned under the Mental Health Act. The company produces original theatre which engages audiences in the issues faced by these women. Through our education and training programme we use theatre and the arts as media which can educate and train and so open up possibilities for women ex-offenders to develop personal, professional and creative skills.

Two women prisoners in HMP Askham Grange founded Clean Break in 1979 and the early encouragement of new writing has been an inspiration ever since. Each year, the company commissions a professional woman playwright to create a new work that is a powerful voice on issues of women and crime. This production tours nationally, sometimes overseas, and is also performed in women's prisons. This year, writer Tanika Gupta researched her play with the assistance of the women and staff at HMP Winchester West Hill Wing and worked with women prisoners to develop their creative writing.

Tanika's commission comes from Clean Break's strong commitment to new writing and its long tradition of working with women playwrights including Lin Coghlan, Kara Miller, Rebecca Prichard, Lavinia Murray, Winsome Pinnock, Louise Page, Anna Reynolds, Sarah Daniels, Paulette Randall and Bryony Lavery.

Clean Break can be contacted at
2 Patshull Road
London NW5 2LB
telephone 020 7482 8600
fax 020 7482 8611
email general@cleanbreak.org.uk

Characters

DI
seventeen year old mixed race woman,
Affy's sister, ageing to twenty-two in Act Three

AFFY
fifteen year old white woman,
ageing to twenty in Act Three

CHLOE
thirty-two year old white woman,
Affy and Di's mum

MERCEDES
Brazilian woman in her late thirties

The play takes place in contemporary Britain
and spans a period of five years

Inside Out was first performed at the Salisbury Playhouse on 16 October 2002, with the following cast:

DI, Natasha Gordon

AFFY, Sarah Cattle

CHLOE/MERCEDES, Connie Walker

Director, Natasha Betteridge

Designer, Atlanta Duffy

Lighting Designer, Catriona Silver

Sound Designer, Sarah Collins

Note

For the purposes of this production, the characters of Chloe and Mercedes were played by the same actress

ACT ONE

Scene 1

We are in the woods, on the banks of a stream.

A young mixed race woman, DI, dressed casually but well groomed, roller-blades up and down, looking for someone.

A young white woman, AFFY, is sat on the bank twiddling her bare feet in the water. She is dressed in her school uniform and her shoes and socks are discarded on the bank. She looks content as she kicks her feet around in the water and reads and re-reads a long letter with obvious relish. She sits in this way for some time.

DI skids to a halt when she finally spots AFFY.

DI: Thought I'd find you here.

AFFY: Fuck off.

> *AFFY surreptitiously puts away the letter. DI doesn't notice.*

DI: Charming!

> *AFFY is silent.*

> You ain't been bunking off again have you?

> *DI squats down next to her.*

> I wouldn't stick my feet in there if I was you.

AFFY: Who asked you?

DI: That water's dirty.

AFFY: Don't care. Feels nice.

DI: Jake said you can get rat syphilis from it if you fall in.

AFFY: Jake.

DI: Is it that fat face cow again? 'Cos if it is, I'll smash her face in for you.

AFFY: Yeah? And make things worse?

DI stops roller-blading.

DI: So, it is fat face? She been nicking your dinner money again?

AFFY: I never said that.

DI looks peeved.

Just enjoying my own company. Thinking.

DI: (*Laughs.*) You? Thinking?

AFFY: Shouldn't you be in the library or something? Revising?

DI: Couldn't face it today. Sun's shining, Jake's pickin' me up later. Goin' down the flicks.

AFFY: Jake.

DI: You can come too if you want.

AFFY: What? And watch him stick his tongue down your throat?

DI: Don't be dirty.

AFFY: Statement of fact.

DI: Can I help it if he can't keep his hands off me? Says I'm gorgeous. D'you wanna know what else he says?

AFFY: No.

DI: Apparently, I'm completely fuckable. My skin's like dark chocolate, my hair's like black candy floss, he wants to grab my arse in his hands all the time and squeeze real hard and bury his face down there…

AFFY: Euch…disgustin'.

DI: My tits are like ripe mangoes…

AFFY: Mangoes?

AFFY laughs.

DI: I think it's really sexy. Turns me on when he talks dirty.

AFFY laughs more.

What?

AFFY: He just sounds like he's hungry. Mangoes, chocolate, black candy floss…

DI: Fuck off.

AFFY: Maybe his mum doesn't feed him properly. He's a skinny bastard.

DI watches AFFY angrily as she has the fits of giggles.

DI: You're just jealous 'cos no bloke wants to go near you.

AFFY: Yeah. Must be it.

DI: Face like a slapped arse.

AFFY: You been lookin' in the mirror again?

DI: Maybe if you tried smiling once in a while some bloke'd take pity on you.

AFFY is silent. DI looks guilty.

AFFY: Jake ever invited you back to his place?

DI: Yeah – loads of times.

AFFY: You been then?

DI: Nah.

AFFY: Why not?

DI: Don't wanna give him the wrong impression.

AFFY: Eh?

DI: He only ever asks me 'round when his parents're out. Basically, he wants a shag.

AFFY: So you haven't done it yet?

DI: Not exactly. I let him touch me an' stuff but…give in too quickly an' they think you're an easy lay. You should get to know Jake. You'd get on. Maybe he could introduce you to one of his mates. You must fancy one of 'em?

AFFY gives DI a look.

Si's alright.

AFFY: Make's me wanna puke just standing next to him in assembly. He stinks.

DI: He does a bit. What about Richie?

AFFY: What about him?

DI: He's your type. Quiet, shy…

AFFY: He's cross eyed!

DI: It's only a little squint.

AFFY: Give over.

DI: Shouldn't be so picky.

AFFY stands up instead and paddles around in the water. DI takes her blades off.

AFFY: You're not coming in are you?

DI: Feet are a bit whiffy…

AFFY: Thought you said you'd get VD.

DI: You can't really get it from your feet…can you?

AFFY: Depends where you put 'em.

AFFY and DI crack up. DI dips her feet in the water.

DI: Oooohhhh…aaaahhhh…lovely…hmmm…

AFFY: Steady on girl.

They laugh again.

We hear the distant sound of a man's voice calling out as they walk. AFFY and DI cower a bit and huddle closer together, as if trying to hide. The voice goes off into the distance.

Is it Godzilla?

DI: No, kids. It's alright. They've gone.

AFFY still looks frightened.

Don't worry, Godzilla'd never come down here.

DI and AFFY play a game with their hands. DI looks closely at AFFY's feet.

You got really weird feet.

AFFY: (*Inspects her feet.*) Eh?

DI: So fucking white – like ghost feet.

AFFY: That's 'cos I am white.

DI: Yeah but they're whiter than the rest of you.

AFFY: Least I don't have to comb the hair on my arse every morning.

DI: Fuck off.

AFFY: Jake like to run his fingers through your bum fluff does he?

DI pushes AFFY roughly.

Temper, temper.

DI: (*Approving.*) You're getting cheeky.

AFFY: Learning how to stand up for myself.

DI: About fucking time.

They both sit for a while paddling in the water.

Where'd you go on Saturday then?

AFFY looks shifty.

Beat.

AFFY: Just went out with some mates.

DI: What mates?

AFFY: I got mates.

DI: Knowing you, you came down here eh?

DI links arms with AFFY.

What's up Affy?

AFFY hangs her head.

Come on tell me.

AFFY: There's nothing to tell.

DI kicks water at AFFY.

Stop it.

DI kicks some more.

Right, that's it. You've asked for it…

DI: No…don't…get off…!

AFFY gets up and tries to shove DI into the water but DI defends herself ably. Instead, they end up in a girly tussle, giggling and screeching. Eventually they give up and sit exhausted on the bank.

AFFY pulls out some sweets from her pocket.

AFFY: Want one?

DI peers at the packet suspiciously.

DI: Yeah – go on.

DI takes a sweet. They both sit and munch together.

What's for tea tonight?

AFFY: Thought you were going out.

DI: I want my tea first.

AFFY: Depends what's in the fridge.

DI: Don't do beans on toast again. I'll end up farting all through the film.

AFFY laughs.

AFFY: What d'you fancy?

DI: Sausages, mash potato and loads of gravy.

AFFY: Takes ages to mash spuds. I was thinking of doing welsh rarebit.

DI: Welsh what?

AFFY: Cheese on toast.

DI: Why d'you call it welsh rarebit? Sounds like a Taff slapper.

They both crack up.

AFFY runs her hands through the water. AFFY pulls out a text book from her bag and rips out a piece of paper. She fashions it into a boat.

Shouldn't rip up school books.

AFFY: Half the pages are missing anyway.

DI picks up the book and looks at it.

DI: It's a fucking library book. You'll get fined you will.

AFFY: Took it from the middle, no one'll notice.

AFFY finishes off the boat and floats it down the stream.

Old Franklin told us they used to drown witches downstream in the olden days.

DI: I thought they used to burn 'em?

AFFY: Some of 'em. But they drowned 'em here. This used to be much deeper. You can see from the banks that the river level was much higher.

DI: (*Yawns.*) Fascinating.

AFFY: Mum told me this story 'bout her bein' followed once down here by a weird bloke.

DI: So you're hanging around here waitin' for him to show up?

AFFY: She was so scared. She was about thirteen an' this woman, all dressed up in olden day clothes beckoned her. Used to be a big tree with a hollow in it. See the stump?

AFFY points to the tree stump.

She told mum if she hid there, she'd be safe.

DI: Right.

AFFY: The bloke came right down to where I'm sittin', looked around, swore a lot and then went on. He didn't even see the woman. She was standing right next to the tree – kind of protecting mum.

DI: Then what happened?

AFFY: She smiled at mum and then disappeared. Vanished like into thin air.

DI: Her and her stories.

AFFY: A week later, they found this schoolgirl strangled further down the path. Mum told the Police what had happened to her, she gave a description and the coppers got him. Locked him up.

DI: Straight up?

AFFY: Mum reckoned she'd been saved by a ghost, a witch who'd been drowned over three hundred years ago.

DI: So why didn't this ghost-witch save the other girl?

AFFY: Dunno. Maybe it wasn't her patch. It was further down the path.

DI laughs.

Makes me feel safe – you know? Like there's someone lookin' out for me. I can feel her.

DI looks at AFFY.

DI: Who?

AFFY: The Water Witch.

DI: What's 'her' name then?

AFFY: Dunno.

DI: I never heard this story.

AFFY: Mum told me it years ago. I couldn't sleep one night. Scared of the dark – told me she reckoned she had a guardian angel that looked out for me.

DI looks away.

You weren't there…out I guess.

Beat.

DI: Fuck wit. If there was such a thing as a witch lookin' out for her, where has she been? Eh?

AFFY: I dunno.

DI calls out.

DI: Oy! Water witch. Come on. Get out here and show your face. We need you!

AFFY: Shh… Di – someone'll hear you.

DI waits for a reply. She looks around her.

DI: So? Where is she?

AFFY: You're bein' stupid now.

DI raises her eyes heavenward.

DI: Had a careers advice sesh today.

AFFY: And.

DI: Waste of fucking time. Trying to persuade me to go into 'retail'.

AFFY: What – you mean like shops?

DI: Yeah. Wanted me to go for an interview as a trainee manager…more like trainee shelf stacker.

AFFY: What did you say?

DI: I told him – I decided what I'm going to be. An explorer. Travel the world. Get on a boat and go…places.

AFFY: What did he say?

DI: Nothing. Just gave me a look.

AFFY: Can't see it.

DI: Why not?

AFFY: You couldn't rough it. Your rucksack'd be like a fucking mountain – jam packed with hand creams and shampoos and crap like that.

AFFY laughs. DI looks put out.

DI: You still want to be a photographer?

AFFY: Yeah. Only not one of them ones that go 'round taking photos of skinny models. I wanna be an underwater photographer.

DI: You still haven't learnt to swim.

AFFY: I will.

DI: You're fucking terrified of jumping off the diving board at the local pool. How you gonna face a shark if you can't…

AFFY: I'll learn. I love fish – I do! They're so graceful and sleek. Gliding around in complete silence. So quiet. I think I'd like it under the ocean.

DI takes her feet out of the water and draws her knees up.

DI: Put you're shoes an' socks back on and let's go home.

AFFY: Oooh look…

AFFY reaches into the stream and pulls out a small shiny pebble.

Pretty isn't it?

DI looks at the pebble.

It's all shiny and glittery – look – it's got little crystals on it.

DI: (*Disinterested.*) Nice.

AFFY: I'm gonna keep this. Be my good luck stone.

DI: Retard.

AFFY: Get lost.

DI: (*Baby voice.*) Oohhh…look at the pretty pebbles…maybe they're fairy stones.

AFFY is silent. She wades out further into the stream to get away from DI.

You fall in an' get wet, mum'll kill you.

AFFY wades further away.

Come on Affy. I got to go home, have my tea, get changed for the flicks.

AFFY: How long you been with Jake?

DI: Couple of months – why?

AFFY: And you've never been to his house?

DI: So?

AFFY: Jessica's been 'round there.

DI: Who's Jessica?

AFFY: Posh girl in my year – Salter's class.

DI: How d'you know?

AFFY: I heard her talking 'bout it today – got double maths with her.

DI looks put out.

DI: What else she say?

AFFY: She'd been 'round for tea, met his mum and dad and she's well into him.

DI: She's lying. What's she look like?

AFFY: Pretty. Blonde. Got a nose stud.

DI thinks.

DI: I know the one. Slag isn't she? What else she say?

AFFY: Described the house. Piano in the lounge, big coffee table…

DI: The bitch!

AFFY: Said he showed her his bedroom and she gave him a shine.

DI is beside herself.

DI: Liar!

AFFY: I'm just tellin' you what I heard.

DI: You're makin' it up. Can't stand that I got a bloke an' you haven't.

AFFY: He's two-timing you.

DI: He ain't like that.

AFFY: How come he ain't ever invited you back to his place then? How come he ain't introduced you to his mum and dad?

DI: He has. It's me. I'm the one who turned down the invitation.

AFFY: Like fuck.

DI: You always do this. Any time I get a little glimmer of happiness – you have to pour cold water all over it.

AFFY: I'm doin' what you told me to do. Bein' practical. Facing facts. Everybody knows what he's like. They're all talking 'bout it – only you're too bloody thick to…

DI: You come here and say that.

AFFY wades out further.

Coward!

AFFY: I'm only tellin' you what the whole school knows. Don't believe me if you don't want to – see if I care. Make a complete arse of yourself.

DI: I hate you!

AFFY: Shoot the bloody messenger.

DI slumps on the bank. She looks very upset. AFFY watches her for a moment.

He's not worth it.

DI is silent.

Honest Di. You're so pretty you could get any bloke you fancied.

DI: I'm gonna fucking kill her.

AFFY is quiet.

Thinks she can nick my boyfriend from under my nose?

DI chucks stones into the stream with fury. One of them hits AFFY.

AFFY: Oy! Watch it!

DI: She went down on him?

AFFY: That's what she said.

DI is thoughtful.

DI: I'm going to slice his balls off.

AFFY: Best ignore it, I'd say.

DI: How can I? Two-timing git.

AFFY: You'll only get in trouble. Anyway, I gave her a good shove in netball.

DI: You what?

AFFY: Pretended to go for the ball but whacked her instead. She fell over, landed on her face and bit her tongue. Blood everywhere.

DI looks at AFFY amazed.

She won't be sucking no cocks for a while. I got sent home to 'cool off'.

DI laughs. AFFY wades a little closer to DI as DI has a good laugh.

DI: Was her pretty face all mashed up?

AFFY: Cut over her eyebrow. She was a bit shaken.

DI: You mean cow.

AFFY: That's me.

DI: Serves her right.

AFFY paddles around.

Hold on. Jessica Slag and Jake the Snake are gonna get talking an' put two and two together. Jake knows you're my sister so…shit…you battered her in in PE?

AFFY: I did it for you. I only tripped her up. She's so flat footed, she fell awkward.

DI: And then Twinkle Toes sent you home?

AFFY: No. Not Twinkle Toes – The head…

DI: Cruella?

AFFY: Yeah. Actually, I think I've been chucked out.

AFFY suddenly looks scared.

DI: You mean – excluded?

AFFY nods. DI looks serious.

AFFY: What am I gonna do?

DI: We'd better go home.

AFFY: They're going to kill me.

DI: Is there anything else you haven't told me about?

AFFY: Jake.

DI: Jake.

AFFY: He called you a nigger. I heard him.

DI: He doesn't mean nothing by it.

AFFY: He shouldn't use that word should he?

DI: What did you do to him?

AFFY: I didn't do nothing to him exactly.

DI: Affy…?

AFFY: Just slashed the tyres on his crappy old car.

DI: Shit Affy. He worships that car. He's gonna be wild. Shit.

AFFY looks upset. DI wades into the water to get her.

I'm taking you home.

AFFY: What's mum gonna say?

DI: I dunno, but we'd better face the music. Come on.

DI hesitates and then clambers up the bank. They exit.

Scene 2

It is later – dusk. AFFY is huddled up on the bank – hair dishevelled – still in her school uniform but looking very traumatised. She is sobbing.

DI: (*Calling offstage.*) Affy? Affy!

DI enters. She sees AFFY and rushes over to her.

Oh Affy – look at the state of you…

AFFY's head remains buried in her arms as she sobs. DI tries to lift her face up.

Let me look at you.

AFFY turns her whole body away. DI looks helpless.

I couldn't get in. He locked me an' mum out…we couldn't get near you.

AFFY: One of these days Di, I'm gonna kill him.

DI: We'll get out. It's only another year. We're nearly there.

AFFY's sobs subside but she keeps her face averted.

AFFY: I fucking hate him.

DI looks upset.

DI: We've gotta go back.

AFFY: No.

DI: He'll be on the warpath.

AFFY: I don't care. I'm gonna to tell someone.

DI: You can't do that. Mam'll get it in the neck.

AFFY: So? He's always slapping her about – what difference would it make?

DI: Difference is, he'd kill her.

AFFY lifts her face. It is smeared and bloody.

AFFY: Why does she let him do this to us?

DI pulls out a tissue from her pocket and starts to dab at the wound on AFFY'S lip.

DI: Let me have a look. He bust your lip.

AFFY: Ouch…

DI: Open your mouth.

DI tries to open her mouth. She starts to cry with pain.

You lost a tooth.

AFFY: Did I? My jaw's hurtin'.

DI: Can you bend your arm?

AFFY shakes her head, still crying.

He do his usual then did he?

AFFY nods.

D'you think it's broken?

AFFY nods. DI examines AFFY's arm.

It's swelling badly. I'm gonna have to take you to the hospital.

DI expertly starts to fashion a sling from a scarf. She's obviously done this before.

But you're not to say nothing. If the nurses ask, tell 'em you got into a fight at school, no on the way home from school. Some kids jumped you an' took your purse. They weren't from our school…they had a different uniform… St Michael's uniform…they're a bunch of wankers anyway. I'll phone home and tell mum where we are.

AFFY: Don't make me go back there.

DI: I'll tell 'em I found you lying on the street… I took you home and realised your arm was busted…that's why the delay in getting you to hospital…didn't realise how bad it was…

DI places AFFY's arm in the make shift sling. AFFY groans with the pain.

AFFY: Please…Di…don't make me go home.

DI: What about mum?

AFFY: She doesn't care.

DI: How can you say that?

AFFY: She doesn't love us. If she did, she'd protect us.

DI: You knew this would happen – you brought this on yourself.

AFFY: I was sticking up for you!

DI: I didn't ask you to. Godzilla's gonna have to pay for those tyres and Jessica's…ten stitches! They ain't never gonna let you back into school again.

AFFY: I did it for you.

DI: I can fight my own battles right?

AFFY is silent.

You say anything to those nosy nurses – you know what'll happen to mum.

AFFY: I don't care.

DI: We've got an agreement!

AFFY: I don't have to put up with this crap anymore. I'm getting out.

DI: And go where? Eh? To one of them Homes? You remember what them places are like. Fucking house of horrors. Shifty social workers, vicious kids, food tastes like dog shit and the bedrooms…

AFFY: I'm getting out.

DI: I won't be there to protect you like I did last time.

AFFY: You can come with me.

DI: They won't take me. I'm seventeen.

AFFY: I've got an idea. We can leave, but not go into one of them Homes.

DI: What?

AFFY: If you leave school and get a flat, you could live in Brighton.

DI: Brighton? We've already agreed what we're gonna do.

AFFY: I think we should both go to Brighton.

DI: For the clubs?

AFFY: And the seaside.

DI: Fuck Brighton and fuck the seaside…

AFFY: Listen to me will you?

DI: No. It's only another year. I decided anyway, change of plan. I'm gonna go for the interview – you know the trainee manager thing. Fuck school. Never going to pass them GCSEs am I? Once I'm earning, and when you've turned sixteen, we'll move out.

Beat.

AFFY: Why wait ?

DI: It won't work now…not 'til your sixteen and I've got a job.

AFFY looks away.

Come on, let's get you to a hospital.

DI helps AFFY up and guides her out.

Scene 3

It is late evening. We are in a lounge. CHLOE enters, takes off her coat and calls out.

CHLOE: Di! Don't you dare give that cabbie a tip. Bastard. I've had enough of his lip.

CHLOE looks around the lounge. She does a quick tidy up, plumping up cushions etc. AFFY enters – her arm in plaster and with a clean sling on. CHLOE helps her.

Come on Princess, sit yourself down.

AFFY hesitates.

Look, I've made it nice for you.

AFFY: Where is he?

CHLOE: He's not here. Come on darlin'. You rest yourself and I'll make you some nice cocoa.

AFFY sits down.

That's more like it.

DI enters.

That cab driver gone?

DI: Yeah.

CHLOE: Nosey old bastard.

DI: You didn't need to go off on one like that.

CHLOE: He should mind his own business – asking my Affy all those questions.

DI: That's 'cos he smelt a rat.

CHLOE: Fuck him.

DI: He was only concerned about your daughter. All banged up like that and you making up that ridiculous story. 'Crashed her bike into a tree'? Why didn't you just say, she walked into a door?

CHLOE: Shut up.

DI sits down next to AFFY.

DI: You alright?

AFFY shrugs. She puts her head on DI's shoulder.

AFFY: A bit tired.

DI: Been a long day.

DI comforts AFFY. CHLOE looks at her two daughters.

CHLOE: That is so sweet. You two stay there and I'll go and make us all a nice hot drink.

CHLOE exits.

AFFY: I don't know what's wrong with you.

DI: Once I'm earning…

AFFY: I decided I'm gonna go to Brighton.

DI: Fuck, here we go again…

AFFY: Brighton.

DI: Where the sun shines all day.

AFFY: I've got it all planned.

DI: Nice sleepin' bag under the pier. Cosy.

AFFY: At first I wasn't sure but now that I've met him…he's a nice bloke…he wants me to live with him.

Beat.

DI: (*Amazed.*) You've met a bloke?

AFFY: It's not what you're thinking…

DI: Who is he?

Beat.

One of mum's punters?

AFFY: Not exactly…

DI: Some dirty old man who wants to shack up with a fifteen year old. You know better than that…

AFFY: He's my dad.

Beat.

My real dad.

DI: (*Laughs.*) Right. 'Course.

CHLOE re-enters. She has a packet of biscuits. She hands them to AFFY.

CHLOE: Milk's still boiling on the pan.

DI: Where's Godzilla?

CHLOE: His name's Ed.

DI: Have you chucked him out?

CHLOE: He probably feels just as bad as we do about…all this.

CHLOE looks awkwardly at AFFY.

I'm sorry babe. I don't know what gets into him sometimes.

DI: Please mum…get rid of him.

CHLOE: How can I?

AFFY: It's easy.

CHLOE: I love him. He's the only bloke whose ever loved me back.

AFFY: What about when he beats the shit out of you? Is that what you call loving you back?

CHLOE puts her hands over her ears.

CHLOE: Stop it.

She rocks backwards and forwards on her haunches.

It's my fault he gets angry. It's all my fault. I egg him on and then he loses his rag and takes it out on my girls.

AFFY watches her mother dispassionately. DI watches her with empathy. She bends down and pulls CHLOE's hands away from her ears.

DI: It's okay mum. It's okay.

CHLOE ignores DI and reaches out for AFFY. AFFY moves away.

CHLOE: I'm sorry babe, my little princess…

AFFY: Shut up will you?

CHLOE: You know I don't want no harm to come to you. You're my little angel.

DI: I think your milk's burning.

CHLOE: Shit.

CHLOE rushes out.

DI: What's this about your dad?

AFFY: I found his address and some letters at the back of mum's drawer. He's been writing to her on and off for years.

DI: You're winding me up.

AFFY: I ain't. His name's Tom and he's a teacher. I wrote to him and he wrote back.

DI: I don't believe you. Mum said she didn't even know who our dads were.

AFFY: He's married with kids. He was still married when he and mum…after you was born.

DI is amazed.

DI: This is doin' my head in.

AFFY: She wasn't on the game for a year. She had this thing with Tom…my dad…but he wouldn't leave his wife for

mum. He sent her money regular like for me – If you don't believe me – look in my pocket.

AFFY leans to one side. DI hesitates.

DI: You always did have an over-active imagination.

AFFY: Look.

DI hesitates more and then fishes in AFFY's pocket. She pulls out the letter, opens and reads.

DI: (*Sarcastic.*) 'My Dearest Aphrodite, How lovely to hear from you…' – fucking posh git. No one calls you Aphrodite – you're Affy.

AFFY: Just read it will you?

DI reads. As she reads to herself, we can see her expression change. AFFY watches her carefully. DI discards the letter.

There's a really nice bit at the end where he says I can live with him…he's got a big house that overlooks the sea…look…there's a photo…

DI: I seen enough.

DI doesn't want to know. She stuffs the letter back into AFFY's pocket.

How come he's being so charitable all of a sudden?

AFFY: His wife died last year.

DI: And she'd never have agreed to you coming to stay.

AFFY shrugs.

AFFY: I'm gonna ask him if you can come and stay too.

DI: Don't be daft.

AFFY: Then we won't be separated.

DI is quiet.

Say something Di. Say you'll come. We're sisters, always been together always will. We don't have to live like this. I'm always scared.

DI: You did all this behind my back?

AFFY: I wasn't sure how you'd take it.

DI: What d'you think I'd do?

AFFY: I dunno. Thought you'd be pissed off with me. All your plans.

DI: They were your plans too.

AFFY: I gotta get out. I can't stand it no more. His stinking breath, his moods, the booze, the nights lying in bed hearing him going at mum. It's disgusting. She cries every day and we all dance his little tune. All three of us. We're like performing fucking monkeys. He's only one man but look at us.

DI: We do it for mum.

AFFY: He's evil.

DI: Better the devil you know…

AFFY: It's getting worse. She's a fucking wreck. I don't wanna end up like her.

CHLOE re-enters with three mugs.

CHLOE: Lost half the fucking milk on the stove.

She hands out the mugs.

Sorry girls.

DI: Thanks.

AFFY is silent. She looks at DI meaningfully.

CHLOE looks at AFFY and DI.

CHLOE: You two plotting something?

AFFY: No.

CHLOE: You're looking all mysterious. What's up Di?

Beat.

DI: Nothing.

CHLOE smiles.

CHLOE: My babies.

Scene 4

It is a glorious day. The sun is shining. DI enters and sits by the river. She looks sullen and angry. She skims stones.

AFFY enters, sheepishly. She looks guilty. She sits down on the bank quietly. DI continues to stand, skimming stones. They don't say anything for a while.

DI: All packed?

AFFY: Yeah.

DI: Great. See ya then.

AFFY looks distressed.

AFFY: You not going to see me off?

DI: No.

AFFY: Di…please…don't be like that…

DI: Like what?

AFFY is silent.

Wanted me to stand in the road waving a white hanky?

AFFY is silent.

Is that bastard coming to pick you up?

AFFY: He ain't a bastard.

DI: Well?

AFFY: I'm getting a taxi to the station.

DI: Just fuck off and go will you?

Beat.

AFFY: I'm sorry things didn't turn out the way they should have.

DI: Right.

AFFY: You should've been nicer to him.

DI: He's a posh git.

AFFY: Why you bein' so nasty? Why can't you be happy for me? It's what we always wanted. To get out of this place.

DI: Together though, not separately.

AFFY: You shouldn't have called him them names.

DI: He shouldn't have wound me up like that.

AFFY: He was only trying to give you some advice.

DI: Don't need no arsehole teacher telling me what's what.

AFFY looks upset.

And as for him goin' to the Police about Godzilla.

AFFY: He got what he deserved.

DI: And did mum get what she deserved?

AFFY: She'll thank me for it one day.

DI: You're beginning to sound like him.

AFFY: How can you stick up for Godzilla?

DI: I'm not sticking up for him.

AFFY: You and mum, you're just as bad as each other.

DI: Fuck off.

Beat.

AFFY looks at her sister incredulous.

You broke your word Affy. I ain't ever gonna forgive you for that. We had a bond.

AFFY: What a vow of silence?

DI: Yeah. You could call it that.

AFFY: All I remember is you making plans and me nodding like a fucking idiot.

DI: That's 'cos I'm older. I always looked out for you.

AFFY: That don't mean you know best.

DI: Thanks for nothing – bitch.

Beat.

AFFY: You want us to say goodbye like this? You could still come down to Brighton, maybe he won't let you live with us but it's a big town…

DI: I'll see how things work out.

AFFY: What if it doesn't work out?

DI: What d'you mean?

AFFY: If you and mum don't get on? If he comes back. You won't stay there if Godzilla comes back will you?

DI: I'm gonna finish school. Pass me exams this time round. Then I'll make me plans.

AFFY: You gotta have a plan now.

DI: Leave it will ya?

AFFY: I'm only thinking about you.

DI: Any plans I make are my business right? I gotta think on my toes now 'cos I ain't got a dad who's gonna suddenly appear out of fucking nowhere, waving a magic wand.

DI is silent.

AFFY: You will come and visit – won't you?

DI: (*Relents a little.*) You think that tosser will let me?

AFFY: 'Course he will.

DI: You could always come and visit us here. Me and mum.

AFFY: Yeah.

DI: Mum'll calm down soon. 'Specially when she starts missing you. You said goodbye to her?

AFFY: She won't talk to me.

DI laughs.

It ain't funny.

DI: She always liked you better and now she's stuck with me.

AFFY: That ain't true.

DI: Never told me stories at bed time to get me to go to sleep.

DI looks away.

Beat.

AFFY: I've gotta go.

DI: Go on then.

AFFY stares at her sister.

AFFY: We ain't ever been apart have we?

DI: Taxi's probably here by now.

AFFY: See you then.

> *Beat.*

I'll give you a ring when I get there.

DI: Might not be in.

AFFY: I'll leave a message then.

DI: Don't let him boss you around too much.

AFFY: No.

DI: And don't get into no fights at your new school.

AFFY: No.

DI: Look after yourself.

AFFY: You too.

> *DI awkwardly picks up a crumpled up carrier bag and hands it over to AFFY.*

What's this?

DI: Going away present.

> *AFFY looks surprised, she peers in the bag.*

AFFY: Where d'you get this from?

DI: A shop.

> *AFFY pulls out a very flash looking camera.*

AFFY: Must have cost a packet.

> *AFFY looks at the camera in admiration.*

DI: You can't take pictures under water with it but I thought you could do with something to start you off.

AFFY: Thanks Di. It's …it's…amazing.

DI: There's some film in the bag as well.

AFFY turns the camera over in her hands.

AFFY: You nicked it didn't you?

DI shrugs and looks away.

AFFY looks longingly at her sister. DI does not return her gaze.

Thanks… It's fantastic.

DI: You like it then?

AFFY: 'Course I do.

DI: Bye then.

AFFY: Yeah. Bye.

AFFY turns to leave.

DI says nothing.

AFFY exits. DI waits until her sister has gone. She doesn't cry but looks distraught. She continues angrily chucking stones into the river.

ACT TWO

Scene 1

We are in a lounge. CHLOE is sitting on a sofa watching the TV. She is dressed too young for her age. She looks upset and has a box of tissues to hand. She has obviously been crying. She swigs from a bottle of beer.

DI enters and looks at her. She sits down next to CHLOE.

CHLOE: I've lost my keys.

DI: Aren't they where you usually keep 'em?

CHLOE: No. Looked everywhere. Might have left 'em in the pub.

DI: Mum!

CHLOE: I know. I'm useless. That's the third set I've lost this year.

She sniffs into a hanky and dabs at her eyes.

DI: You been blubbing?

CHLOE: No.

CHLOE snuggles up to DI. DI looks uncomfortable. DI peers at the screen.

DI: Don't recognise anyone in this film.

CHLOE: Looks old.

DI: Looks bloody ancient.

They sit in silence together for a while.

CHLOE: She gone then?

DI: Yeah.

CHLOE looks upset.

Said she'd phone tonight.

CHLOE: Her room's completely empty.

DI looks upset.

DI: She knows her own mind. You gotta give her that much.

CHLOE: She's really gone?

DI: Yeah mum.

CHLOE: Just me and you now.

DI: Right.

CHLOE: Didn't think she'd really do it. You should have talked her out of it.

DI: Wouldn't listen to me.

CHLOE puts her arms around DI and then clings on to her tightly.

(*Laughs.*) Get off mum! You're squeezing me.

CHLOE: You won't ever leave me like that will you?

DI: Can't stay here forever.

CHLOE: No. But you don't have to go yet. A couple more years – eh?

DI: Sure.

CHLOE: My girls, all grown up.

CHLOE strokes DI's hair.

Such pretty hair. You should let me put some more oil in it – it's getting dry at the ends.

DI wriggles free and stands up.

DI: You hungry?

CHLOE: Not really.

DI: I'm going to get myself something to eat.

DI exits. CHLOE flicks through the TV channels with the remote control.

The theme tune to BLIND DATE blares out. CHLOE sits up in her chair, happier now.

DI calls out.

How about some welsh rarebit?

CHLOE looks confused.

CHLOE: Welsh what?

DI: (*Calls out.*) Cheese on toast.

CHLOE: Nah.

DI: (*Calls out.*) Sandwich?

CHLOE: Okay.

CHLOE watches the TV. She giggles childishly. She sticks her thumb in her mouth.

DI re-enters holding up a set of keys.

DI: Look what I found?

CHLOE: They're mine. Where were they?

DI: In the fridge.

CHLOE: (*Giggles.*) What am I like?

She takes the keys and puts them in her handbag.

DI exits again. CHLOE sticks her thumb back in her mouth and watches the TV.

(*Calls out.*) Come and look at this Di. There's a coloured girl…looks like she's got snakes in her hair.

DI: (*Calls back.*) They're braids mum.

CHLOE: Whatever.

CHLOE rummages around in her handbag and produces a lipstick and a small mirror. She gets busy applying her lippy. She looks at the TV and undoes a few buttons and pushes out her breasts.

Get a load of that darlin'. Much better looking than those bitches.

She laughs.

DI re-enters with two plates. She hands one to her mum and sits down on the couch. DI munches away.

DI: Come on mum – eat.

CHLOE: I'm not really hungry.

DI: You got to keep your strength up. You don't eat properly. Always chips in the middle of the night. It ain't good for you.

CHLOE nibbles at her toast.

CHLOE: (*Pointing at the TV.*) He's a cracker. Gorgeous. Euch – Look at her…fucking snotty cow…who does she think she is? Never understood the attraction of Cilla Black. Carrot-haired – all teeth and no tits.

DI: Apparently she's rolling in it.

CHLOE: Reminds me of great aunt Sarah. Used to babysit for us. Right up until she was eighty years old, she had hair same colour as Cilla. Your uncle Dan said it was a wig stuck on her head with copydex. I believed him and tried to pull it off once.

DI laughs.

She beat the living daylights out of me. Had this walking stick she used.

DI: How old were you?

CHLOE: Only little. Dan thought it was a great laugh. But it hurt you know? She was always doing that. How's Affy going to cope without us?

DI: She'll be fine mum.

CHLOE: She must really hate me to break my heart like this.

DI: (*Sharp.*) It's your fucking fault.

CHLOE: I loved her didn't I?

DI looks away.

DI: I was thinking of going down to Brighton.

CHLOE is silent

You want to come with me?

CHLOE: No.

DI: Why not?

CHLOE: She betrayed me.

DI: Bollocks mum.

CHLOE: Don't you swear at me.

DI: Affy's got sense. She left because…

CHLOE gets jumpy.

CHLOE: Don't start Di.

DI: What is it with you? Why don't you ever face facts?

CHLOE: My little princess…turns her back on me and runs away. If she thinks we're not good enough for her, fucking good luck to her.

DI: She wouldn't have gone if it hadn't been for Godzilla and you know that. You heard from him?

CHLOE: No. I expect he's well pissed off with us. It wasn't right what Affy did.

DI looks at her mother incredulous.

We're in for it now.

DI: He fractured her arm, bust her lip…broke her tooth… and you should've stopped it.

CHLOE is silent as she watches the box.

CHLOE: The blonde one's a sweet looking girl. If he had any sense – he'd go for her.

DI turns her attention to the television screen.

DI: He can't see her though. He has to go on what they say.

CHLOE: Shame.

DI: He'll go for the smart one.

CHLOE: He'll crap his pants when he sees she's coloured.

CHLOE laughs uproariously.

DI: (*Annoyed.*) Shouldn't make any difference.

CHLOE: Fucking ugly twat. (*Shouts at the telly.*) Shut your face. Let Blondie get a word in. (*Moans.*) Ohhh…idiot… he chose the wrong girl!

DI watches the telly angrily.

…stupid grin's been wiped right off his fucking face. (*To the telly.*) Weren't expecting that were you? (*To DI.*) Get me another beer will you?

DI: Get it yourself.

CHLOE: Oh go on. Be nice to your mum.

CHLOE kisses DI all over the face.

DI: Get off!

CHLOE: Please…pretty please…

DI extricates herself and marches out again. She re-enters a few moments later with a bottle of beer.

DI: You drink too much.

She hands the beer over to her mum and then sits at some distance. CHLOE looks at her.

CHLOE: That father of hers. Says I'm not fit to be a mother.

DI: Well…he's right isn't he? Hold on…you spoken to him?

CHLOE: He phoned me. The nerve of the man. Even wrote me a letter.

DI: When?

CHLOE: Few days back.

DI: Where is it?

CHLOE: I put it down somewhere…

DI: What did it say? Did you read it?

CHLOE: You know how crap I am with letters…

DI: Where is it?

CHLOE shrugs.

Mum!

DI gets up and searches the room. She looks in CHLOE's handbag and then down the back of the sofa. She finds it

stuffed down the side. It is all crumpled up. DI opens the letter. She reads it quickly.

CHLOE watches the TV.

CHLOE: What's he going on about then?

DI: (*Reading.*) Hospital was in touch.

CHLOE: Eh?

DI: Hospital got in touch with him about Affy. That's why he persuaded her to move in.

CHLOE: How come the hospital had his address?

DI: She must have given it to them.

CHLOE: Like father like daughter. Two of them probably plotted it all well in advance.

DI paces and reads the letter.

DI: You should've read this… Tom's applied to be her legal guardian now and he's taking proceedings against you.

CHLOE: Me? What have I done?

CHLOE looks worried.

They won't throw me in jail will they?

DI: Dunno.

CHLOE: I didn't do nothing wrong.

DI: Didn't do nothing right either. You'd better phone him – talk him out of it.

CHLOE: I'm not phoning him.

DI: You gotta sort this out mum, else you'll be in deep shit.

CHLOE: You do it. You're much cleverer than me.

DI: You're the mum – they'll send you to court – not me.

CHLOE looks afraid.

CHLOE: 'Sppose I had it coming. Always made friends with the wrong people. I'm fucking useless I am. It's just, I get so confused. And now my princess hates me.

DI: She hates Godzilla – not you.

CHLOE: Hope he leaves us alone.

DI: He won't – you've just got to be ready for him.

CHLOE: But he's gone away.

DI: He'll be back. Maybe we should move.

CHLOE: He'll find us. He said to me once – wherever I went, he'd track me down. If he couldn't find me, then someone else would.

Beat.

DI: He said that to me too.

CHLOE looks at DI and wraps her arms around her. This time, DI doesn't squirm in her mum's embrace.

CHLOE: He's gone now though. We're safe Di. You and me. We can do whatever we want. We don't have to live by his rules.

DI: Maybe, Affy's done us a favour.

CHLOE: You won't leave me will you love? I couldn't cope on my own.

DI: I'm not going anywhere.

DI holds CHLOE.

He's gone now mum.

CHLOE: And so has our Affy.

DI looks away, upset.

Never mind Di. We'll make the most of it. You and me – eh? I'll try better. I'll be a good mum. I promise.

CHLOE strokes DI's hair lovingly. They both settle down in front of the box. DI looks almost content, snuggled up with her mum.

Scene 2

It is a month later – late in the evening. CHLOE is sat on the floor playing Patience. The TV is on in the background. The phone rings. She answers it.

CHLOE: Hello…?

Beat.

Hello?

CHLOE's face drops. She looks scared. She slams the phone down. Within seconds it is ringing again. She hides behind the settee staring in fear at the ringing phone. DI enters, with a carrier bag full of shopping. She sees her mother cowering behind the sofa. CHLOE points at the phone. DI knows the score immediately. She dumps the bag and heads towards the phone.

Don't Di. It's him.

DI ignores CHLOE and answers the phone.

DI: Hello…she doesn't want to speak to you and neither do I. We got an injunction out against you so you can't come anywhere near this place.

CHLOE looks terrified.

I'm not threatening you – just telling you. Right?

DI clicks the phone off. She drops down next to CHLOE and eases her up.

CHLOE: He's back.

DI: He can't touch us mum.

CHLOE: He'll come after me.

DI: There's nothing to be scared of.

CHLOE: He's gonna kill me.

DI: No. I'm here. You mustn't worry. Look at you!

DI smoothes back her mother's hair. CHLOE continues to shake.

CHLOE: It's the waiting that gets to me. The time in between – before the next beating…

DI: There won't be a next time. Remember what I said mum. When he phones, hang up.

CHLOE: That's what I did – then he phoned right back.

DI: If he tries to approach you on the street, in a shop, anywhere, you walk straight past him, you ignore him and walk away.

CHLOE: What if he grabs me?

DI: He's not allowed to.

CHLOE: You think a piece of paper's gonna stop him?

DI: He's out of our lives mum – we've got to keep it that way. You've got to be strong.

CHLOE: Strong.

DI: You're not going to let him back in are you?

CHLOE: No. Never.

DI: You promised me.

CHLOE: I meant it.

DI: Remember what the solicitor said. If you show him any weakness he'll be straight back in here.

CHLOE: Yeah.

DI: Never open that front door until you've checked first.

CHLOE: But he's got a key.

DI: We changed the locks – remember?

CHLOE: Oh yeah.

DI: And please – don't go boozing in that Three Bells again.

CHLOE: But my mates…

DI: Tell 'em you'll meet them somewhere else.

CHLOE: You're so fucking bossy.

DI: That's 'cos I've got to think for both of us.

CHLOE jumps as she hears a crash of bins outside the house.

CHLOE: (*Terrified.*) That's him!

DI switches off the light and walks to front of the stage and peers out at the audience, as if she is peeking out of the windows.

DI: It's just kids.

CHLOE: You sure?

DI: Little bastards…they've emptied the bins in front of old Jackson's house.

CHLOE gets up and peers out at the audience – afraid.

CHLOE: Look!

DI: What?

CHLOE: Ed's car.

DI: Where?

CHLOE: Across the road.

DI: Is that his car?

CHLOE: Can't you see him?

DI looks hard. CHLOE gets more and more scared.

He's watching us.

DI: I can't see anyone.

CHLOE: He's sitting there in the front seat – biding his time.

DI: Mum…

CHLOE: He's there! Look!

DI stares hard.

DI: There's no one there.

CHLOE: I just saw something move.

DI: I didn't.

CHLOE: He's there Di. I know it. He's waiting for me… waiting 'til it's quiet.

DI looks at her scared mother sadly.

DI: There's no one there. That's not his car and there ain't no one sitting in it.

The two women continue to look out into the darkness. The door bell rings. CHLOE nearly jumps out of her skin. DI freezes.

CHLOE: Oh my God…shit…

DI: Stay put. I'll deal with it.

DI exits slowly to the front door. CHLOE looks terrified. She waits. The door slams.

CHLOE: (*Calls out.*) Who is it?

DI re-enters with AFFY.

AFFY: Hello mum. (*Laughs.*) What are you doing in the dark?

CHLOE is beside herself with joy.

DI switches on the lights.

CHLOE: You came back! You came back!

CHLOE leaps up and hugs AFFY tight.

My baby, my baby's back.

CHLOE continues to hug AFFY.

AFFY: Mum, let go… I can't breathe.

CHLOE continues to cling to AFFY. DI has to try and extricate her mum.

DI: Give her a break mum – you'll suffocate her.

CHLOE doesn't want to let go. It takes a while between AFFY and DI to pull her off AFFY.

CHLOE: Where are your bags?

DI: What you doing here?

AFFY: Charming. Thought you'd be pleased to see me.

DI: I am but…

AFFY: I've only come for a visit.

CHLOE: He's gone now. You can stay.

AFFY: Godzilla's gone?

CHLOE: He's never coming back here.

AFFY: Straight up?

CHLOE: You don't need to go and live in Brighton anymore.

Beat.

AFFY: I'll stay the night but I've got to get back to school on Monday.

Beat.

CHLOE: Should be grateful you came to visit your old mum eh? Your dad treating you right?

AFFY: Yeah.

CHLOE: What about his other kids?

AFFY: I've met them. They're dead old.

CHLOE: He abandoned me – don't you forget that. Minute I was pregnant with you, didn't see him for dust.

AFFY: I think that's why he wants to make it up. He feels guilty.

CHLOE: He fucked me over.

DI: Mum…

CHLOE: Just warning her. He could run out on her just as easily as he did me. Promised me the world. Make your sister a nice cup of tea Di.

DI sits down on the couch.

DI: She knows where the kettle is.

CHLOE looks daggers at DI.

What? Suddenly I'm the fucking housemaid?

CHLOE takes AFFY by the arm and leads her to one side.

CHLOE: Take no notice of her.

AFFY looks over her shoulder at DI.

My little angel. You went in such a hurry, I never got a chance to give you nothing.

AFFY: You don't have to mum.

CHLOE takes off a chain from around her neck and puts it around AFFY's neck.

CHLOE: A lucky horse shoe. Real gold. Belonged to my mum. You wear that and you'll always be happy.

DI watches.

Now sit down and tell us all about your adventures.

AFFY sits down next to DI. DI ignores her.

AFFY: Nothing much to say. Big house, lots of empty rooms. Tom says you could both come and stay – if you want. How've you both been?

DI: We're fucking skint.

AFFY: How come?

DI: Mum's not working anymore.

AFFY looks delighted.

AFFY: Brilliant!

CHLOE: You could get off your arse though couldn't you?

DI: I've got to finish me exams first.

CHLOE: What's the point of exams? If you strutted your stuff a bit more, we could get some proper cash. Men pay well for black pussy.

AFFY looks horrified.

AFFY: Mum. That's a disgusting thing to say.

CHLOE laughs.

CHLOE: I was only joking – wasn't I Di? You know I was only joking.

AFFY looks at DI with sympathy. She changes the subject.

AFFY: My new school's great. Teachers seem okay – far as teacher's go.

CHLOE: Been down the Pier yet?

AFFY: Only once…spent a lot of time on the beach though. Love the sound of the sea. Been too cold to go swimming but…

CHLOE: That's where I met your dad. Did he tell you that?

AFFY: Eh?

CHLOE: On the Pier. I was having my palm read by this gypsy woman and Tom was waiting to have his read. He bought me some candy floss.

CHLOE giggles at the memory. AFFY and DI exchange a look.

Does he talk about me much?

AFFY: (*Awkward.*) A bit.

CHLOE: He was a nice man. Shame he was married really. Very loyal to her he was.

DI: Obviously.

CHLOE: He always sent me money. He was very good like that.

AFFY stands and walks away. She is finding the conversation unbearable.

DI: Like your trainers.

AFFY looks down at her feet.

AFFY: Thanks.

DI: Diesel.

AFFY: Yeah. He took me shopping.

DI: S'alright for some.

AFFY: Only problem was, he insisted on coming with.

DI: Shame.

AFFY: Should have seen him fussing in the shops. Kept going on about wearing sensible clothes.

DI laughs.

DI: What a pain.

AFFY: Wouldn't let me buy half the things I wanted. Said they were too revealing or not 'appropriate'. He likes that word 'appropriate'. I threw a wobbly in the end. Called him an 'old fashioned git'. He was shocked. I don't think anyone's ever talked to him like that before.

DI: Sounds like an arsehole.

AFFY: Nah. He's alright. At least he cares.

CHLOE: I cared – just couldn't afford to spoil you.

AFFY: He's got loads of dosh mum – credit cards, cheque books – even got savings. (*To DI.*) You seen Jake?

DI: No.

AFFY: He still mad?

DI: Yep.

AFFY: Skinny little runt.

DI: I'm steering well away from blokes. Nothing but bad news.

CHLOE: We should have a special meal tonight – celebrate.

DI: What for?

CHLOE: Affy's visiting.

CHLOE jumps into action and starts rummaging around in drawers. She pulls out some candles. AFFY and DI watch her.

DI: We haven't exactly much food.

CHLOE: I'll have a scout around the kitchen. I'm sure I can come up with something.

CHLOE exits.

AFFY: Godzilla really gone?

DI: Yep.

AFFY: For good?

DI: Got an injunction out on him.

AFFY: How's she been?

DI: You can see for yourself. I didn't know you were coming to visit.

AFFY: Thought I'd surprise you.

DI: We only spoke this morning.

AFFY: It was hearing your voice…had to come…

AFFY starts to sob.

DI: Hey? Hey! What's up?

DI moves over to AFFY.

AFFY: It's such a mess.

DI: What is?

AFFY: I thought I was doing the right thing.

DI: What's he done to you?

AFFY: Nothing.

DI: You sure? If he's laid a finger on you…

AFFY: No – he's bent over backwards to get me on my feet. He's really sweet.

DI: So why are you bawling?

AFFY: It's not the same. I was so desperate to get away from this dump and Godzilla but now…

DI: What are you going on about?

AFFY: I miss you and mum.

DI: Jesus Affy – this was your fucking doing.

AFFY: I know.

DI: You got in touch with him, you fucked off and left me to deal with her…how dare you feel fucking sorry for yourself?

AFFY continues to sob.

DI sits close to AFFY.

Suddenly CHLOE enters.

CHLOE: Ta-taaa!

She is carrying a tray full of lighted candles with a hunk of bread and cheese on it. A couple of bottles of beer grace the tray as well.

Not exactly the feast I had in mind – but it's the thought that counts.

She places the tray on the table. AFFY and DI gather around.

AFFY: Actually I'm starving.

DI: Me too.

CHLOE takes out a large knife and cuts the cheese rather desperately whilst DI cuts the bread.

AFFY: Careful mum.

DI hands out the bread; CHLOE, huge slabs of cheese.

DI: Jesus mum…

CHLOE: Just eat it.

CHLOE pours three glasses of beer. The girls munch hungrily.

DI: (*Laughs.*) Look at us.

CHLOE: That's the last of the beer. Don't know what I'm going to live on now.

AFFY: When's the next Giro?

CHLOE/DI: (*Together.*) Friday.

AFFY: This reminds me of the picnics you used to take us on – remember mum? When we were little? Down by the river?

DI: Hunks of bread and cheese…

AFFY: …And melted chocolate rolls.

DI: All over your face and hands. Only time we looked like sisters.

CHLOE: Bet you won't be able to have such a laugh with that old man of yours.

AFFY: No. He's a bit serious but he's dead clever. Wants me to go to University.

CHLOE: University?!

DI: That's a great idea.

AFFY: I've got a lot of catching up to do before I can even think about going to University.

CHLOE: That'd be something though – wouldn't it? Imagine!

DI: You could get a really good job. People with degrees get paid loads.

CHLOE: Eh – Affy – Me and Di'll be knocking on your door every day goin' – 'Lend us a fiver.'

AFFY: I could buy us all a big house to live in.

CHLOE: With a swimming pool….

DI: And a butler…

AFFY: And a huge tank with tropical fish.

CHLOE: And I want a really fit toy boy to rub sun tan lotion into me back…and maybe my front too.

AFFY: So you're not angry with me anymore. I am sorry. It's just, I couldn't…

CHLOE: You did us a favour. It was a bit of a shock what you did, but in the end Ed's gone and I'm never letting him back in here again. And it's all thanks to you Affy.

CHLOE raises her glass.

To Affy. The one member of this family who's gonna make something of her life.

AFFY: Mum – what about Di?

CHLOE: Di's like me – a hustler.

DI: I'm not like you.

CHLOE: Face it darling.

DI: (*Deflated.*) No.

AFFY: Let's just drink a toast to the future – to us. We got rid of Godzilla, we're free.

CHLOE raises her glass.

To all of us.

DI grudgingly raises her glass. The phone rings. CHLOE and DI freeze as they stare at the phone.

Scene 3

It is a few weeks later, early in the morning. DI is padding around the lounge in her night gear. She pours herself a bowl of cereal and settles down on the sofa when she notices a pair of men's shoes on the floor. She gets up and examines the shoes. Then she picks up the leather jacket hanging on the back of the armchair and smells it. Her reaction shows who the jacket belongs to. She looks shocked at first and then devastated. Almost immediately, she makes a decision. Pulling on some clothes hurriedly, we see her in a frenzy of activity, packing a bag, collecting her things. The front door slams and CHLOE enters, still dressed in her gladrags. She has obviously been out all night. CHLOE takes her high heeled shoes off and sits rubbing her feet. DI watches her.

CHLOE: Shouldn't you be at school?

DI: It's Saturday.

CHLOE giggles.

CHLOE: Oops. Lost a day there.

She notices DI putting on her jacket.

Where are you going?

DI: Brighton. I did tell you. Remember?

CHLOE: Oh yeah. How're you getting there?

DI: Train. Affy sent me the fare.

CHLOE: Should be nice by the sea. Looks like it's going to be a sunny day for you.

CHLOE spots the men's shoes. She hurriedly picks them up to try and move them out of the way. DI watches her.

CHLOE looks guilty.

Couldn't get rid of him. He's still upstairs.

DI: Got a guilty conscience have you?

CHLOE: No.

DI: You should have.

CHLOE: We need the money.

DI: You got no self-respect.

CHLOE: It's my money keeps us going.

DI: You could get a job. A proper one.

CHLOE: Who'd give me a job?

DI: There are lots of things you could do.

CHLOE: What? You want to see your mum cleaning shit off toilets, cleaning up after other people's mess?

DI: And you'd rather open your legs and let 'em fuck you instead?

CHLOE looks upset.

CHLOE: It's what I know best.

DI: Maybe your best isn't good enough.

CHLOE watches DI – puzzled.

CHLOE: Why are you being so nasty?

DI: Why d'you think?

CHLOE: What? Just because I brought someone back.

DI: Don't play the innocent…

CHLOE: This is my house. I'm allowed to…

DI: I recognised this jacket and those shoes…

CHLOE looks guilty.

DI goes out back. CHLOE sits looking worried. She slips her thumb into her mouth for comfort. DI re-enters carrying a holdall.

CHLOE: Why you taking such a big bag?

DI: Visit Affy and then I'm going to try and make it on my own.

CHLOE: No, you can't.

DI: Watch me.

CHLOE: What about me?

DI: I can't look out for you anymore.

CHLOE: Please…

DI: You brought Godzilla back here. You promised me.

CHLOE: Di…

DI: Is he actually upstairs right now?

CHLOE: Don't shout. Don't want to wake him up.

DI: You been out all night…

CHLOE: It was a good night – He's got me new punters.

CHLOE produces some cash from her handbag which she shows to DI.

Here, have some. Treat yourself in Brighton.

CHLOE reaches out to hand DI the money but DI throws it back at her instead.

DI: I was in this house on my own with him sleeping in the next room? You didn't think to tell me?

CHLOE scrabbles around on the floor, picking up the money DI threw back at her.

CHLOE: He gave me his word he wouldn't touch you again.

DI: You gave me your word you wouldn't let him back in again.

CHLOE: I went down the Three Bells. And he was there.

DI: I told you to stay away from that place.

CHLOE: He's changed Di. He's learnt his lesson.

DI: Oh please…

CHLOE: He went down on his knees to me. He begged my forgiveness. Imagine! Ed begged me?! In front of everyone. I looked into his eyes and I could see…he was a different bloke.

DI: You're such a fucking idiot.

CHLOE: Don't call me that!

DI: You believe him? After everything he's done?

CHLOE: This time it'll be different.

DI: It won't mum.

CHLOE: I won't let him touch you. I'll protect you.

DI: What like you did when I was thirteen years old?

CHLOE looks away.

Me and Affy would have crawled through fields of thorns for you…

CHLOE throws herself on the floor and grabs DI's legs in her arms, trapping her.

DI: Let go mum.

CHLOE: No. You can't walk out on me.

DI: Mum…

CHLOE: Everyone's walked out on me. That's all they ever do.

DI: I can't live like this.

CHLOE: I'll change.

DI looks tired. She bends down and forcibly removes CHLOE's arms from around her legs.

DI: You let him back in again. He turns on the charm and you fall for it hook, line and fucking sinker. He'll beat you, scare you, put you on the street, take your money and then he'll start on me. And d'you know something? I don't want to fucking end up like you. You're disgusting.

CHLOE looks at DI with fury.

CHLOE: At least I'm white you bag of shit.

DI looks shocked. She puts on her jacket with dignity and zips up her holdall.

CHLOE runs out of the room. DI picks up her bag and walks towards the door with it. CHLOE comes running from the back with a kitchen knife in her hand. She blocks DI's path. DI looks scared.

DI: What are you doing? Put that knife down.

CHLOE: Can't believe you came from me. Nigger, coon…devil! You were the one who turned my Affy against me. Always whispering to her at night, filling her

head with questions. Should have given you up. That's what I wanted to do – that's what my mum told me to do…

DI stands her ground.

DI: Why didn't you mum? I could've had a family – a normal family. Imagine.

DI heads towards the door.

CHLOE: You ain't going anywhere. Sit down.

DI keeps moving towards the door.

You ain't leaving.

DI: I am. Now stop being stupid.

CHLOE: You think you can speak to me like I'm just rubbish?

DI: You are rubbish. I should have listened to Affy – should have left with her. Wasting my fucking time feeling sorry for you.

CHLOE: I don't need your pity.

DI: Put the knife down.

CHLOE: I'll use it. I'll cut you up so badly, no man'll come near you.

DI: Mum…

CHLOE: What have I got to lose?

DI: Don't do this.

CHLOE: After all I've done for you.

DI: You haven't done nothing for me. Always loved Affy more, always treated me second best.

CHLOE: D'you blame me?

DI: Thought you'd be pleased to see the back of me.

CHLOE: You owe me. A life for a life.

DI: What are you talking about?

CHLOE: My mum threw me out because of you. Half-caste, frizzy haired, bastard. I should have chucked you in the bin the day you were born. My whole life ruined – because of you.

DI: Get out of my way.

CHLOE: No!

DI walks resolutely towards the door.

CHLOE lunges at DI.

There is a struggle and the two women fall to the floor. As the lights go down, there is a scream.

ACT THREE

Five years on.

Scene 1

It is a sunny day. MERCEDES, a thirty-something woman, stands outside the prison gates. She paces impatiently, looking at her watch. She is wearing a large pink ostrich feather scarf and is clutching a bottle of champagne. Eventually we hear the long groan and creak as prison doors open and then slam shut. MERCEDES stops pacing and looks up expectantly. DI emerges, carrying a large black bin liner/bag over her shoulder. She stands and savours the sun. MERCEDES shrieks and runs towards her.

MERCEDES: (*Brazilian Accent.*) At last!

DI: Mercedes.

The two women hug briefly. DI looks up at the sky.

MERCEDES: What a lovely day! A fucking beautiful day. (*She sings.*) 'The Sun has got his hat on – hip – hip – hip – hooray…! The sun has got his hat on and he's coming out to play…'

The two women laugh and dance around excitedly. MERCEDES places the ostrich feathers around DI'S neck.

DI: Can't believe you came.

MERCEDES: Where else would I be?

DI: Actually, I thought they'd have sent you back to Brazil.

MERCEDES: They threaten to deport me and in a way, I am hoping they will, because I am so home sick…but my brother – he sort things out for me. I get a visa – another six months.

DI: It's great to see you.

MERCEDES: Welcome to the outside. Come on let's get out of here.

The exterior of the prison gates merges into a bar. We hear Bosa Nova playing in the background. DI and MERCEDES sit down at a table drinking beer. DI looks around with interest.

DI: Nice place.

MERCEDES: It makes me feel like I am at home.

DI: That hostel they've put me up in's a dump isn't it?

MERCEDES: You won't have to stay there long.

DI: I've heard Suzie's there as well.

MERCEDES: (*Incredulous.*) They let her out?

DI: She got out on appeal.

MERCEDES: Jesus Christ. She is mad. Remember when she set fire to that fat screw's uniform?

DI: Yeah? And when she cut up that nonce's face with those scissors?

MERCEDES: My needlework scissors.

DI: We all got into hot water over that one.

They sip their wine and contemplate.

MERCEDES: Can't imagine Suzie on the outside. I mean what would she be doing with her time?

DI: Winding up the neighbours, shouting at the shop keepers.

MERCEDES: And flying around on her broomstick howling at the moon.

They both howl at the moon together and then crack up.

MERCEDES: You must keep away from her Di. In fact – always be careful.

DI: I can look out for myself.

MERCEDES: Yes, yes…but you must not get too friendly with old inmates. They are bad company – yes? Always getting in trouble, mixing with the wrong sorts…they will make problems for you.

DI: Mercedes, what about you? You're an ex-inmate. Should I avoid you?

MERCEDES smiles and pours DI some more wine.

MERCEDES: Me. I am the worst.

They raise their glasses to each other.

To the future and your freedom.

DI: Freedom.

They sip their wine.

MERCEDES: Now, we must make plans. Benefit is on the way, probation officer has seen your face.

DI: Poor bugger. He looked totally knackered.

MERCEDES: English skin – it wrinkles quickly with stress.

DI: D'you reckon they make things deliberately difficult for us?

MERCEDES: Of course. They make the punishment last longer. No one want to help us. I have my brother when I come out. He help me – otherwise, I would have killed everyone then I would be back inside. We need to find you a job.

DI: That ain't gonna be so easy.

MERCEDES: I have same problem. – I not think a bank would employ me. 'Mrs Da Fonseca. Can you tell us, have you any experience in the banking industry?' 'Yes sir. I have worked seventeen of your branches.' 'And what department was that in?' 'Cash transactions sir.'

MERCEDES and DI crack up.

You and me Di. We make enough money and we go back to Rio – where the sugar loaf mountain rises high above the city and the sands are fine and yellow.

DI: That sounds very tempting. But we'd need to make a lot of money.

MERCEDES: I could get you some work as a cleaner – like me. The pay is shit – yes – but we can save. There are many, many rich people where I live. There is this advertising woman whose house I clean. Her house – so big and only her and three cats and a dog live there. I clean, and another woman walks the dog for her. Imagine! Sometimes I find little mirrors covered with powder on her dressing table.

DI: Coke?

MERCEDES: (*Nods.*) Other times, I find ten – twenty pound notes all rolled up tight, which she has dropped down the side.

DI: And you swipe 'em?

MERCEDES: Of course. After I have licked the money clean. Ten pounds to me is a lot of money. To her, it is nothing. She spends that much on a smelly candle.

DI: I thought you were supposed to be turning over a new leaf?

MERCEDES: I am not a fool. I am finding it, she is losing it and I am keeping it.

DI: (*Looks around the bar again.*) Can't believe the amount of fucking mobile phones. Everyone's got one.

MERCEDES: The world has moved along in five years.

DI: And the shops.

MERCEDES: I keep away from shops. Too much temptation.

DI: Selling so many things. And people walking so fast.

MERCEDES: People are always busy.

DI: Kids everywhere.

MERCEDES: That is one of the good things about being outside. Children.

MERCEDES leans forward.

How are you feeling?

DI: Weird.

MERCEDES: Good weird or bad weird?

DI: Actually, a bit pissed weird.

They laugh.

MERCEDES: How were all my girls when you left?

DI: Ibi's still there – waiting to get her transfer. Sharon's waiting to be released and Nadia and Ling– they've all been flown back home – serve the rest of their sentences in their countries – don't suppose we'll ever see them again.

MERCEDES: (*Raises her glass.*) Good luck to them all.

The two women fall into silence for a while.

Hey, Di, you need a fix?

DI: I'm clean.

MERCEDES: I still need it.

DI: It'll kill you.

MERCEDES: Like everything else. But look, I have something to show you.

MERCEDES produces a piece of paper from her pocket. DI looks at it.

DI: It's in Portuguese…

MERCEDES: Look at the second word…

DI: 'Mama'… Your boy? Is this from Paulo?

MERCEDES: I find him again. And I have a photo.

MERCEDES produces a photo.

DI: He's got hair on his face.

MERCEDES: He's a man – Seventeen years old. Last time I see him he was just eleven.

DI: Very handsome. Looks just like you.

MERCEDES smiles, takes the photo back, kisses it and starts to dance and sway to the music.

MERCEDES: He is living in Rio now with his father. We must go there to see him. You will come with me – yes?

DI: Yes. What about his dad…?

MERCEDES: He is still a shit. Says he is ashamed to call me his wife. But oh no, he does not believe in divorce, so I am still Mercedes Da Fonseca. But my Paulo, he go behind his father's back, and write to me. A clever boy.

DI watches MERCEDES as she dances. She looks wistful.

You look sad. Don't look sad. I look after you.

DI: I'll be fine.

MERCEDES: You just have to know what you want.

DI: I know what I don't want.

MERCEDES: Another drink?

DI: No, it's going straight to my head. Don't want to end up throwing up on my first night on the outside.

MERCEDES: You take it easy eh? Mercedes will look out for you. Mercedes will protect you. It is a beautiful world out there full of wonderful people. The trick is to pick your way through the rubbish and never to look back.

DI smiles. She looks around the bar again.

DI: God all these people – can go anywhere they want. Do anything – don't have to ask for permission to take a piss…

MERCEDES reaches over and kisses DI on the forehead.

MERCEDES: First week, everything will be strange. One minute you will be like a child. Marvelling at everything. The trees, the roads, the people, the clothes. Next minute you will be terrified. Second week, you will feel tired. Third week you will feel lost. Fourth week you will spend every day pissed and stoned out of your head. Fifth week you will wake up in the mornings and wonder whether they will accept you back in prison. Sixth week you will have a rage in your head against everyone. And so on. After two maybe three months you will start to feel normal again.

DI: Don't even know what normal is anymore.

MERCEDES looks at her son's photos again.

MERCEDES: I would do anything to see him again.

Beat.

DI: Did you get her number for me?

Beat.

MERCEDES: Give it a few days.

DI: You found out where she lives?

MERCEDES: Why you want to spoil your first moments of freedom?

DI: She's my sister. I need to see her.

MERCEDES: Why? Five years – no visit – no word – not even a letter. Why you need to see her?

DI: So I can move on.

MERCEDES: How you move on with her? She is like a weight tied around your neck. Better to untie the knot and step away.

DI doesn't look convinced.

DI: I need to tell her.

MERCEDES: Tell her what?

DI: That I'm sorry.

MERCEDES: She should be saying sorry to you. She abandon you – she leave you to rot. What she care?

DI: I killed our mum.

MERCEDES: And you have been punished.

DI: I need to say 'I'm sorry'. I need to explain it all.

MERCEDES: And what if she don't forgive you?

DI: At least I'll have said it.

MERCEDES sighs and pulls out another piece of paper from her pocket. She hands it over. DI takes the paper and looks at it.

She's still living in Brighton? Are you sure this is the right address?

MERCEDES: My friend – he can find me anyone in the country. He help me.

DI looks at the paper for a long time.

DI: I'll go down and visit her next week.

MERCEDES: You are still on licence.

DI: Whose gonna know?

MERCEDES: You cannot go down to Brighton just like that. We must speak with your probation officer first.

DI: No. I'll be alright.

MERCEDES: You will not be alright. You will go straight back in. Infringement of the law – you are licensed for life.

DI: Don't fucking start.

MERCEDES: No. You must do these things properly. You want you should go back into prison?

DI looks thoughtful.

DI: Of course I don't want to go back in.

MERCEDES: Then, first you must ask for the permission. And you must at least phone her.

DI: Yeah.

MERCEDES: Otherwise, she may be horrible to you. You are so steady, maybe, seeing your sister again will send you over the edge.

DI: I'll expect the worse.

MERCEDES: Families fuck you up Di. I should know. Maybe going backwards is not such a good idea.

DI: She's the only family I got.

MERCEDES: A half-sister who does not want to know you?

DI: I just need to see her. Know that she's alright.

MERCEDES looks wary.

MERCEDES: And then we find you a nice boyfriend – yes?

DI: Please.

MERCEDES: A handsome, gentle boy who will rock you to sleep and help you dream well.

DI: Stop it.

DI picks up her jacket and bag as she and MERCEDES leave the bar.

MERCEDES: Someone with strong arms and eyes only for you. Every woman must have a good lover.

DI: You find yourself a bloke first and then come and lecture me.

MERCEDES: Maybe we both wait until we're in Rio. The English men, they are not so good between the sheets.

They laugh and exit.

Scene 2

We are in a lounge. The left overs of dinner are on the table and the TV is on. The phone rings. AFFY enters. She grabs the phone.

AFFY: Hello…hello…?

She looks at the phone annoyed.

Come on – who is it? Hello?

Losing her patience, she slams the phone down in disgust.

Nutters.

She busies herself clearing the mess – putting toys back in a box and shoving them out of sight. When she's done, she fetches herself a beer and settles in front of the telly with it. The door bell rings. She looks annoyed. The door bell rings again.

For fuck's sake…

She goes to the door and re-enters a few moments later followed by DI. AFFY looks quite obviously shocked. DI is dressed smartly. She looks directly at AFFY.

DI: Thought I'd drop by.

AFFY is speechless. She sits down.

Aren't you gonna ask me to sit down?

AFFY nods. DI sits down.

Nice pad. Should see the place I'm holed up in.

DI looks AFFY up and down.

Still as scrawny as ever.

AFFY: You look great.

DI: I do my best.

AFFY: When did you get out?

DI: Last week.

AFFY stares at DI.

You look like you've seen a ghost.

AFFY: It's just…just a bit of a shock…

DI: How've you been?

AFFY: Fine. How d'you find me?

DI: A friend of a friend… Ain't you gonna ask me how I am?

AFFY: How are you?

DI: What d'you care?

Beat.

AFFY: Why've you come here?

DI: Wanted to see my sister.

AFFY: You could've warned me.

DI: Thought I'd surprise you.

DI walks around the lounge and surveys it. AFFY watches her – edgy.

You live here on your own?

AFFY: No.

DI: You got a bloke?

AFFY nods.

AFFY: Sean.

DI: You gonna introduce me?

AFFY: He's at work.

DI: At this time?

AFFY: He's a cabbie.

There is an awkward silence.

What was it like…inside?

DI: Pretty shit. Got moved around a lot. Last place I was in was okay. Worked in the garden, took some GCSEs and an 'A' Level.

AFFY: (*Surprised.*) You got some qualifications?

DI: Yeah. How about you?

AFFY: Never finished school.

Another awkward silence.

DI: You married?

AFFY: Engaged.

DI: Sean treat you well?

AFFY: Yeah. But we're broke. He's got two jobs just trying to make ends meet.

DI: Don't you work?

AFFY: Not at the moment – no.

DI: Thought you were going to be an underwater photographer.

AFFY: Never learnt to swim.

DI laughs. AFFY watches her warily.

Must have been lonely in prison.

DI: I made friends.

AFFY: Where'you staying?

DI: Mate's house in Manchester. Kipping on her floor.

AFFY: You came all the way down from Manchester?

DI: Don't worry – I'm not gonna crash here. I got another mate, lives nearby. Said I could stay at hers. How's Tom?

AFFY looks down.

AFFY: He had a heart attack. Died a couple of years ago.

DI: I'm sorry.

AFFY: Are you?

DI: Yeah. He did right by you – in the end.

AFFY: He was a good bloke. He left me a bit of money – I put it down as a deposit on this place. What are your plans now?

DI: Start work next week.

AFFY: You've only been out a week and you've already got a job?

DI: It's only bar work – my mate fixed it up for me. Her brother runs a bar.

AFFY: You seem to have a lot of friends.

DI: Lots of friends in low places. Bar work isn't exactly the way I want to go but it's a start.

AFFY pulls out a carton of cigarettes. She offers one to DI.

Thanks, but I don't smoke.

AFFY lights up.

I hear they knocked our old house down?

AFFY: Built new flats.

DI: Would've liked to have seen the place again.

A baby cries from the back room. DI looks startled. AFFY gets up.

AFFY: I'll just settle her.

AFFY bustles out of the room. DI looks amazed. She notices a toy tucked under the settee. She picks it up and turns it in her hand. AFFY returns.

I think she was having a bad dream.

DI: You've got a baby?

AFFY: Yeah.

DI: I never knew.

AFFY: Actually, I've got two.

DI: Can I see them?

AFFY: I'd rather you didn't – they'd get scared if they saw a stranger in their bedroom.

DI: How old are they?

AFFY: The little one's six months – that's Katie – and Kiren's two.

DI: You have been busy.

AFFY takes some photos out and shows them to DI.

Fuck Affy – you're a mum. That's amazing.

AFFY smiles for the first time.

AFFY: Not getting much sleep but they're both gorgeous. Kiren's just starting to talk. Says 'mummy', 'daddy' and Thomas.

DI: Thomas?

AFFY: Thomas the Tank Engine.

DI laughs.

And Katie's sitting up on her own, with lots of cushions stuffed behind her. Sometimes she keels over and falls flat on her face.

DI: She looks just like you did when you were a baby.

AFFY: You think?

DI: Oh yeah – especially round the eyes.

AFFY: She's got her dad's sticky out ears.

DI: I didn't like to say.

They laugh.

AFFY: They're lovely kids.

DI: Do they even know they've got an auntie?

AFFY: No.

DI: And Sean? He know about my existence?

Beat.

AFFY doesn't answer, but looks away.

DI looks upset for the first time.

Must be tough looking after two kids.

AFFY: Yeah. Most of the time it is me on my own. Sean's always working. He's a hospital porter during the day.

AFFY lapses into silence.

DI: So, didn't you get through your exams?

AFFY: Too many other things to worry about. Once the kids are up and running – maybe I'll go back to college. I feel like I owe it to Dad. How did you cope inside?

DI: I got through it.

AFFY: Is it as nasty as they say it is?

DI: Yes and no. It's the boredom and the petty regulations that get to you more than anything else.

AFFY: Must be a bit scary being out.

DI: It's more exciting. Feel like I'm holding my breath all the time trying to stop myself.

AFFY: Stop yourself?

DI: From going over the top. Laughing like a maniac, crying like an idiot – that sort of thing. Got to hold it in. I did a lot of yoga inside.

AFFY: You? Yoga?

AFFY laughs long and hard.

DI: It's very calming. You should try it. It helps to centre things.

AFFY: Right, between the feeds, the nappy changes, the trips to the park, the visits to the doctors, the shopping – I got loads of time to sit on my fucking arse and chant.

DI: You got what you wanted.

AFFY: What d'you mean by that?

DI: This life…

AFFY: I wanted a family if that's what you're getting at.

DI: You're lucky. I'd like kids one day.

AFFY gives her sister a look.

You never know.

AFFY: Want a beer?

DI: No – thanks…

AFFY: A coke?

DI: Go on then.

AFFY goes to the fridge and pulls out a can of coke. She hands it to DI.

Ta. How'd you meet Sean?

AFFY softens a bit.

AFFY: You won't believe this.

DI: Go on.

AFFY: He lived next door. When I moved back to live with dad, Sean's family were our neighbours.

DI: (*Laughs.*) You fell in love with the boy next door?

AFFY: Yeah. Should have seen me Di. Spent ridiculous amount of time in that back garden with dad digging, weeding, planting.

They both crack up.

Even started fucking sunbathing in my bikini in the summer.

DI: You never!

AFFY: Nearly got pneumonia. Still, wasn't long before we were having long chats over the garden fence.

DI: It obviously worked 'cos here you are.

AFFY sighs.

AFFY: Yeah. Here I am.

DI: I did a lot of gardening too. Around this time, I'd be putting away all me tools. Screw would be checking everything, making sure I hadn't nicked anything. Terrified they are that I'll go to work on one of them with a pair of shears. After that, I'd have one last glance around, make sure everything was looking good...

AFFY: Never imagined you as a gardener.

DI: Can't see out of the prison, windows all face in. In the garden, you'd see the beginnings of the sunset and then the sun'd dip down beneath the walls. Ripped to shreds by razor wire. That's what it looked like. Ripped and bleeding into the sky.

AFFY: (*Gentle.*) Now you can see as many sunsets as you like.

DI: Did you go to mum's funeral?

AFFY: Yeah.

DI: They wouldn't let me. Was Godzilla there?

AFFY: Crying like a baby. He got sent down you know.

DI: I heard.

AFFY looks surprised.

Prison grapevine.

AFFY: Got caught this time. Raped a thirteen year old girl.

DI: He always did like 'em young.

AFFY shifts uncomfortably.

Still, no point dwelling in the past eh? Got to move on. Wanted to see you. Thought about you a lot.

AFFY: I thought about you too.

DI: You never came to see me. Didn't you even want to hear my side of the story?

AFFY: She was my mum.

DI: Who you fucking left.

AFFY: However awful she was, she was still my mum.

DI: You weren't there, you didn't see what she was like.

AFFY: Then why didn't you leave?

DI: She brought Godzilla back after everything.

AFFY: That's no excuse for what you did.

DI: I see.

AFFY: What d'you see?

DI: I came by because I needed to know where we stood.

AFFY: What did you expect? A welcoming party? Balloons? Banners? What?

DI: No. I thought you might have forgiven me. I regret what I did and I'm sorry.

AFFY: You're sorry. How can you live with what you did?

DI: Five years isn't enough punishment? It was self-defence.

AFFY: That's bullshit. Mum would never have attacked you. She was weak, completely vulnerable – that was her fucking problem. Never learnt how to stand up for herself.

DI: So you don't believe me? You'd rather believe all that shit you read in the papers?

AFFY: You stabbed her eight times. That's not self-defence.

DI: She was my mum too.

AFFY looks away.

I was the one who stayed behind to look out for her. Tried to protect her from that animal. She was her own worst enemy.

AFFY: Listen to yourself! You expect me to fucking feel sorry for you? After you ripped the heart out of our family.

DI: We didn't have a family.

AFFY: You can't just come back into my life now and mess things up. I'm sorted, I've got a routine.

DI looks hurt. She covers up.

DI: Fine. Can't I just see the kids?

AFFY: I'd rather you didn't.

DI gets up and paces. AFFY watches her for a moment.

She'd always come between us Di. What you did – how we lived. I don't want to remember those days.

DI: Neither do I but sometimes Affy, you got to face it – or you get stuck. And it'll come back to haunt you when you least expect it to.

AFFY: What, like you came back to haunt me?

DI: Don't you feel even a tiny bit responsible?

AFFY: What? For murdering our mum?

DI: For abandoning me.

AFFY: I was fifteen years old.

DI: And what about me? Didn't you ever think about how it would affect me? She pulled the knife out on me first. That's when I realised that it wasn't him that was the enemy. She was.

AFFY: But mam…she gave you life.

DI: And she sucked my life from me. Where was the joy? The fun? Seventeen and feeling like all the troubles of the world was on my shoulders. And where were you?

AFFY: I had to save myself.

DI: Our mum sold me – like a slave at a market – from the age of thirteen, I was giving blow jobs to Godzilla's mates for ten quid a hit.

AFFY looks horrified.

AFFY: You should have told someone.

DI: I was scared.

DI looks at AFFY.

AFFY is silent.

And you left 'cos you didn't want to go the same way as me. Did you?

AFFY looks up at DI.

AFFY: Can you really blame me?

AFFY and DI stare at each other.

DI: You left me behind. And then you pretended I didn't exist.

AFFY: It was hard for me too. I was trying to make a new life.

DI: You're just like mum.

AFFY: Don't say that.

AFFY starts to cry. DI watches her impassively.

You don't know what it's been like for me. Keeping everything together – don't want anyone to know – about my family. I got kids now. Gotta protect them.

DI: From me?

AFFY: From the past. My mum the fucked-up tart who was murdered by my sister. And then there's me Dad – every time he looked at me I could see the guilt in his face…all of you gone – I had to fend for myself. No point in feeling sorry for myself.

DI: I didn't go away. I was just locked up.

AFFY: Locked away from me.

DI: It was your choice not to see me.

AFFY: I couldn't cope – not with you on the inside and me outside – couldn't even finish school. I was a mess. If Sean left me. If anything happened to the kids – I spend my life worrying that I'll lose everyone. That's why I keep away from people. Don't make friends easy – never have. People let you down don't they? Can't trust no one…

DI looks at AFFY with pity.

Beat.

You were supposed to be the strong one. You were supposed to look out for her – for all of us. You failed.

DI: So did you. And I wasn't strong – not back then.

Beat.

AFFY: I tried to imagine you inside, wondered what you were doing, how you were coping…scared me just thinking about it.

DI: I'm here.

Beat.

AFFY: He'll be back soon. It's best you leave.

DI: Right. Are you going to tell Sean about me?

AFFY: He knows.

DI: You said…

AFFY: I told him. When we first met. It was hard to miss – it was all over the papers. He won't want you near the kids.

DI: And what about you? Is that what you want? So that's it?

AFFY: We can't ever go back to the way we were Di.

DI: (*Angry.*) No. But I expected a bit more from you or are you too weak to stand up to your bloke?

AFFY: Don't.

DI: Another man controlling your life…

AFFY: Stop it.

DI: First Godzilla, then Tom and now Sean.

AFFY: I don't want to fight. I'm tired.

DI: Not as fucking tired as I am. Jesus Affy.

AFFY: Get out of my house – please. He'll be back soon.

DI: Not until you tell me to my face.

AFFY: What?

DI: That you never want to see me again.

Beat.

AFFY: We'll always be sisters.

DI: Yeah – and?

AFFY: It won't work.

DI looks upset, she breaks down.

DI: She came at me with the knife. She called me names – disgustin' names. She said she should've chucked me in the bin when I were born.

Beat.

She tried to stop me from leaving. I was coming to see you…she hated me – how can a mam hate her own flesh and blood like that? She wanted to kill me. Called me a nigger.

AFFY: I didn't know.

DI: You never asked me. Sometimes Affy, I look at my hands and I wonder 'Are they really a part of me?' Why didn't I just batter her? I could've made a run for it then… Then I think – I'm a murderer – is that what people see when they look at me? Can they tell?

AFFY: You're not a murderer. You just got landed with a shit deal. Maybe I would've done the same.

DI: Why did she do that to me Affy?

AFFY: She were mad.

DI: Why couldn't she have loved me the way she loved you?

AFFY: She knew she couldn't survive without you – neither of us could.

DI: The funny thing is – when I came out of prison – I almost expected to see her. I actually miss her.

AFFY: Me too. How fucked up is that?

DI: Why didn't you write? Would have made the world of difference to me.

AFFY: I'm sorry Di.

DI: You couldn't even give up a single afternoon for me?

AFFY: I'm sorry.

DI sits in silence for a moment and then stands up again.

DI: I'd better go.

AFFY: No, stay.

DI: But your bloke…?

AFFY: Don't worry about him.

DI: I don't want to cause trouble for you.

AFFY: You won't. We'll explain it to him – together.

DI: (*Uncertain.*) You sure?

AFFY nods.

AFFY: You want to see the kids?

DI: Please.

AFFY gets up and leads DI out. DI hesitates before following her.

Scene 3

MERCEDES and DI are down on Brighton beach. We hear the waves crashing. DI is skimming stones whilst MERCEDES is sat with legs splayed apart, facing the sea.

MERCEDES: You can feel the pull of the waves, just here.

She feels her belly.

It is very sexy feeling.

DI: (*Laughs.*) With you Mercedes – everything's about sex.

MERCEDES: I am from Brazil.

DI looks out to sea.

DI: It's what I missed the most. Water, the sound of it, the feel of it. Kind of feel disorientated when you're landlocked.

MERCEDES rolls a joint.

MERCEDES: That is because women need water…it is all connected here. (*She points to her stomach.*)

DI: I guess you're right.

MERCEDES: You come with me to Brazil and I will show you the Amazon. Pink dolphins, rain forest, crocodiles, parrots, mangrove swamps.

DI: You'll have to teach me Portuguese.

MERCEDES: Sure, no problem.

DI: Which way is Rio anyway?

MERCEDES peers out to sea. Then she turns and looks behind her.

MERCEDES: You see that fish and chip shop? It's behind there – about a few thousand miles in that direction.

DI: A long way.

MERCEDES: Not so far by plane and much hotter when you get there. In the summer, everyone wanders around wearing bikinis – except the men of course – although anything goes in the carnival.

DI: Mercedes – are we going to survive out here?

MERCEDES: We are never going back there – never.

DI: What about you?

MERCEDES: Eh?

DI: Are you going straight?

MERCEDES smokes the joint.

MERCEDES: 'Course.

DI: You won't let me down?

MERCEDES: What you think?

DI: What if things don't go your way…if we never make it to Rio?

MERCEDES: We have to have a dream. No use cutting it down before we started.

DI: What if it all goes wrong and you go back to robbing banks?

MERCEDES: It won't go wrong.

DI: How much money can you make cleaning houses and working a bar? It ain't gonna be that easy Mercedes.

MERCEDES: We must have a plan.

DI: I'm sick of making plans.

MERCEDES smiles.

I don't wanna clean houses or serve drinks.

MERCEDES: You want to leave me behind?

DI: No. But Rio's your dream. I've got my own.

MERCEDES: I know.

MERCEDES watches DI with a mixture of pride and sadness. DI smiles and spreads her arms out and enjoys the sea spray on her face.

DI: Feeling good.

MERCEDES: Live life to the fullest.

DI laughs.

Fall in love.

DI: Have babies.

MERCEDES: And hold them close to you.

The sun breaks through.

All that time we spent inside, you always talk of baby sister.

DI: I worried about her. That was my job.

MERCEDES: And now?

DI: Old habits die hard. I still worry about her but she'll be alright – we all will.

MERCEDES: You think that maybe we should eat some fish and chips?

DI: Yes. I think maybe we should.

DI and MERCEDES turn and walk away together. MERCEDES sings: 'The sun has got his hat on...'

The lights fade.

End.